Vasari,
Michelangelo &
the *Allegory of Patience*

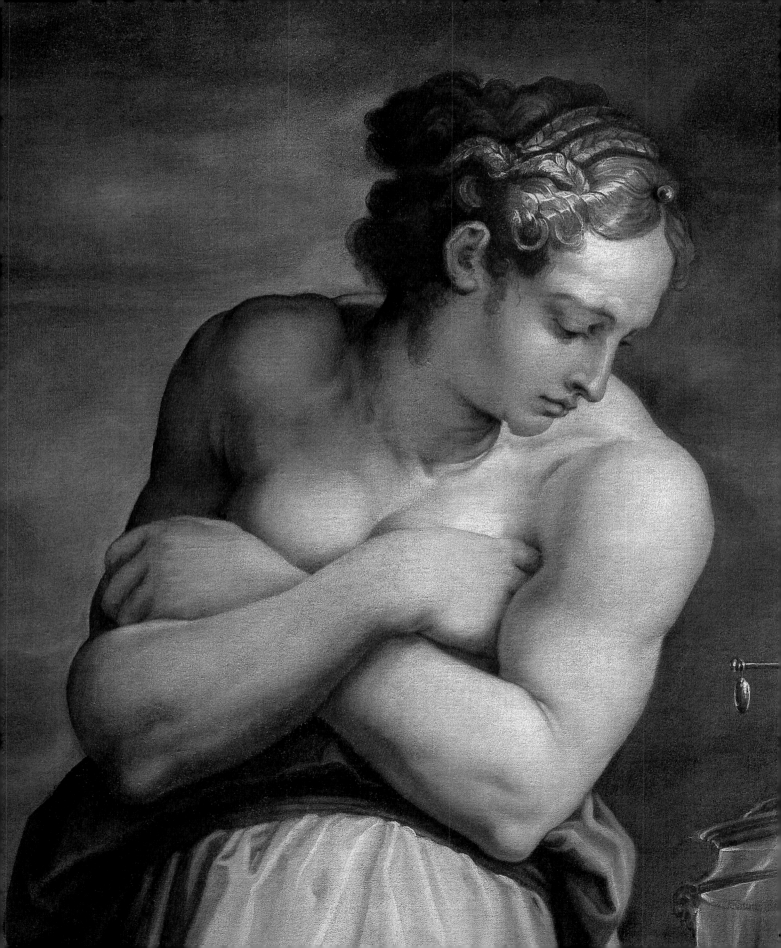

Vasari, Michelangelo & the *Allegory of Patience*

CARLO FALCIANI

CONTENTS

5 Foreword
PATRICIA LEE RUBIN

7 Vasari, Michelangelo *&* the *Allegory of Patience*
CARLO FALCIANI

12 The *Patience* in Vasari's correspondence

19 Vasari's autograph work

21 The iconography, the Florentine replicas,
the Emilian variants

45 Michelangelo's "invenzione"

53 Notes

56 Colophon

FOREWORD

PATRICIA LEE RUBIN

Giorgio Vasari (1511–1574) was not known for his patience. He was, however, widely admired for his abundant inventiveness and equally abundant energy. By 1550, though of modest origins, the painter from Arezzo had produced a significant body of work on all scales and in all genres, fulfilling commissions in remote monasteries and in major centres like Florence, Bologna, Venice, Naples and Rome. As able with his pen as with his brush and devoted to the cause of his art, that year he also saw the publication of his virtually unprecedented book of biographies of artists from Giotto's time to his own. Moreover Vasari possessed a remarkable gift for friendship. He could count among his friends and supporters noble lords, wealthy merchants, men of letters and high-ranking clerics, including the Florentine Bishop of Arezzo, Bernadetto Minerbetti – one of the protagonists of the intriguing story that follows here and that began not long after the publication of *The Lives*. The others are none other than Michelangelo Buonarroti (the 'divine'), the humanist

Annibale Caro, and the Duke of Ferrara, Ercole II d'Este. The story is one of mistaken identities, intense desires and dramatic discovery. The identities involve the authorship of a series of paintings of the figure of Patience ultimately derived from a design by Vasari which was based on ideas that arose in conversations in Rome with his friends Michelangelo and Caro. The desires were first those of Minerbetti for a work that bore the imprint of Michelangelo's genius, if not his hand, and that emblematized the patience of a long-suffering upbringing, and subsequently of the Duke for a version of the resulting painting. The discovery is Carlo Falciani's, who recognized Vasari's hand and Michelangelo's poetic conception in the exquisitely rendered *Allegory of Patience* published here. With wonderful patience on his part, Falciani has traced the genesis of work, sorting out and giving new meaning to the copies and variants generated by the statuesque beauty who submits so gracefully to the passage of time.

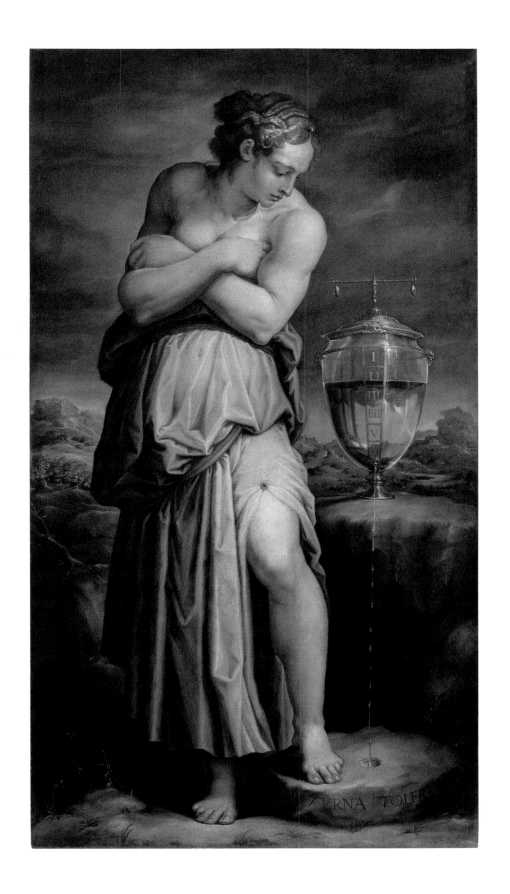

Vasari, Michelangelo & the *Allegory of Patience*

CARLO FALCIANI

The re-emergence of a painting will sometimes enable us to reappraise an artistic question even after its figurative and documentary elements have acquired over time – in the absence of the most important piece of the puzzle – what had appeared to be unquestionably an established and solid interpretation. Such is the case with the *Allegory of Patience*, a work painted by Giorgio Vasari for the Florentine residence of the Bishop of Arezzo, Bernardetto Minerbetti, which from 1551 was the object of an intense exchange of letters between the patron and the artist. It is here published for the first time after centuries of oblivion. The evidence provided by the style of the painting, entirely consistent with that of Vasari, the presence of the motto *diuturna tolerantia* created for Minerbetti by Annibale Caro, and the correlation between the dimensions of the composition and those recorded in Vasari's letters – as well as with those of the various Florentine and Ferrarese copies – means that no further grounds remain to challenge the attribution of this work of incomparable quality to the hand of the Aretine master. However, in the light of this rediscovery, the entire question requires revision in order fully to penetrate the meaning of the allegory, which is a rhetorical construction based on a small number of symbolic elements, and to give an order to the various known versions – direct copies, derivations, or iconographic variations – which are not always consistent in their relation to one another in the chronological sequence proposed to date by scholarship.

I

Giorgio Vasari
Allegory of Patience
Oil on canvas, 197.8 × 108.8 cm
London, The Klesch Collection

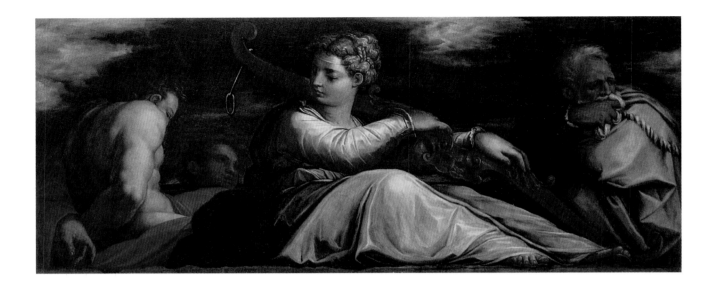

Taking the exchange of letters between the patron and the artist as our starting point, we should recall that Minerbetti had chosen Patience as his emblem when still a youth, in memory of the injustices he had endured over many years at the hands of an uncle to whom he was beholden for subsistence.[1] Now a grown man, he had asked Vasari to create a new allegorical representation of the state of mind that the artist had already depicted in Palazzo Corner following Renaissance convention – a woman with a yoke by her side – a representation that does not seem to derive from classical tradition.[2]

Hitherto the Minerbetti *Patience* has been identified with a canvas, hanging in the Palazzo Pitti, which first appears in the inventories of the Medici collections in 1675, at the time of Cardinal Leopoldo, listed as by Parmigianino. This is a troubling attribution for a painting for which one would expect an illustrious provenance and an association with the master that would surely not have been overlooked while Vasari continued to enjoy a god-like status in the world of Tuscan art well into the seventeenth century. In subsequent Grand-ducal catalogues – those of Inghirami, Bardi and Chiavacci[3] – the work now hanging in Palazzo Pitti was instead ascribed to Francesco Salviati. This attribution attempted to take into account the clear evidence of Michelangelo's influence

2

Giorgio Vasari
Allegory of Patience
Oil on panel, 79 × 188 cm
Venice, Gallerie dell'Accademia

3

Bastianino e Camillo Filippi
Allegory of Patience
Oil on canvas, 178 × 102 cm
Florence, Galleria Palatina
di Palazzo Pitti

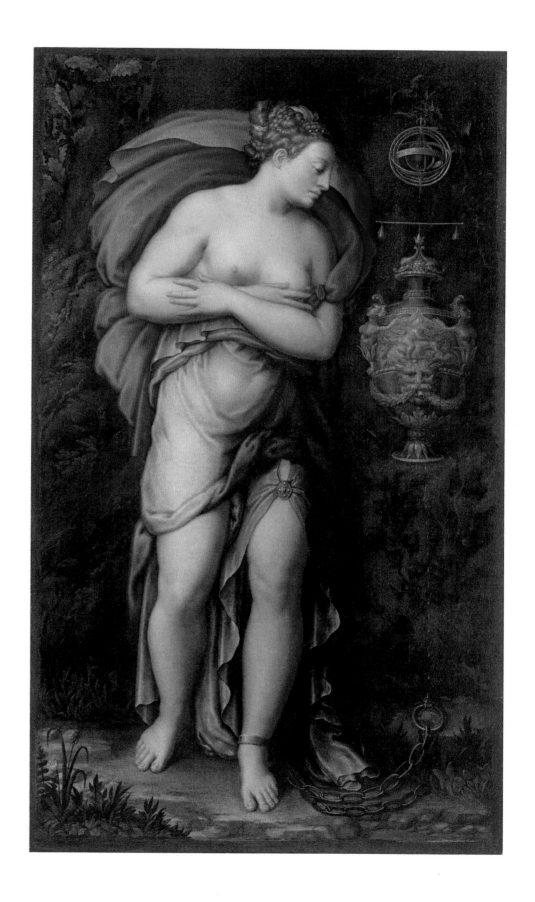

in the monumental stature of the female figure so far removed from Parmigianino, and also the soft and smooth handling of the paint and the fluid lines of the rippling folds of the drapery, rarely encountered in Vasari's works, or indeed in Florentine painting more generally, except in the works of Salviati. These characteristics are still today the most conspicuous stylistic elements of the Palatine painting, together with the proliferation of decorative detail in which the painting is steeped, redolent of the art of Parma – the gilded bronze of the water clock richly adorned with figures and blade-like leaves, like gilded wisps of straw; the teeming roots breaking through the ground, and the variety of plant species, each and every one identifiable, with which both the foreground and background rocks are strewn with a botanical exactitude absent in Vasari and even in Salviati. The attribution to Cecchino Salviati was accepted by Venturi, while Voss in 1920, and later Stechow in 1935, were the first to attribute the painting to Giorgio Vasari, a suggestion followed by several scholars after Frey's publication of Vasari's correspondence, which includes his copious exchange of letters with Minerbetti on the subject of the *Allegory of Patience* – letters in which the descriptions of the painting seemed to correspond to the Palatine painting. Federico Zeri raised a voice of dissent: studying the Pitti canvas in 1951 with the eyes of a connoisseur, and not recognizing in it the hand of a Florentine artist, he suggested it was the work of Girolamo Siciolante da Sermoneta, an artist able to endow Michelangelesque solidity and monumentality of form with painterly sensibility. On the other hand, the attribution to Vasari was accepted by the Vasari scholars of the latter half of the twentieth century, in particular by Kliemann in 1981, Costamagna in 1988, and Corti and Mortari in 1989 and 1992 respectively.[4]

The gulf separating the subject matter (consistent with the description of the painting sent by Vasari to Minerbetti in a well-known letter) and the style, in no way characteristic of the works of the Aretine artist, seemed to have been resolved when, more recently, the painting was attributed to the hand of Gaspar Becerra, the Spanish artist who had been Vasari's collaborator in Rome in the Sala dei Cento Giorni, mentioned by Minerbetti himself in a letter of 5 May 1552, a letter linked to the *Allegory of Patience*.[5] "Becerra removed a certain number of specks (*bruscoli*), which had fallen and stuck to that Madonna della Costanza, and this evening, I believe, he will arrange (*acconcierà*) the Patience, and he has heaped praises

on everything"[6] – an imprecise expression, "*acconcierà*", in a letter in which the bishop informs the painter (who was in Arezzo) of the execution of a number of specific operations carried out in Florence by his collaborator. That Becerra was to *acconciare* the Patience that very evening should never have been interpreted as allowing the possibility that he was responsible for the material execution of the work, which, from the perspective of modern connoisseurship, presents a facial type scarcely resembling the physiognomies of Vasari's figures, as well as his draperies unlike Vasari's, which in the mid-sixteenth century are always sharp-edged. The hypothesis could be supported by letters written at the time of the *Allegory*'s conception, in which the patron had proposed to Vasari that, should he find himself short of time and unable to fulfil his request, he should entrust the execution of his design to a young painter. An attribution to Becerra seemed therefore the perfect solution of the problem, although the works of that artist painted both in Italy and in Spain are characterized by a Michelangelesque style that appears simplified and dry, at times rough, and influenced above all by Michelangelo's later paintings in the Pauline Chapel. Becerra's paintwork does not have the same soft and almost creamy appearance, or the overabundant decorative and naturalistic detail that are defining characteristics of the *Patience* in the Palazzo Pitti. Revisiting the entire correspondence, one comes to realise that the whole sequence of events in fact leads to a quite different conclusion, for in the letters and *ricordi* subsequent to the delivery of the work in early 1552 (Becerra was summoned to *acconciarla* on 5 May of that year) the references are always to a painting executed by Vasari himself.

Although some of the letters may be missing, by matching up the documentary and artistic evidence it is possible to unravel the whole question of the *Allegory of Patience*, the key to the solution being the present painting – unequivocally a masterpiece by Vasari's hand, and consistent in its dimensions and iconography with the work requested by Minerbetti. Proof of this reconfiguration of the evidence is the whole series of Florentine and Ferrarese copies and derivations on the same subject. These can now, thanks to the re-emergence of the present painting, be put into a different and definitive chronological sequence in the place of the one which until today seemed consistent with the requirements of the court of Ferrara, requirements which would not, of course, have entirely coincided with those of the Bishop of Arezzo.

The *Patience* in Vasari's correspondence

In a despatch sent from Rome and preserved in a copy taken by Giorgio Vasari the Younger, the artist told the Bishop of Arezzo of meetings that he had had with Michelangelo in order to find an allegorical figure to represent 'Patience', going on to describe the image accompanying the missive with a drawing, now lost. Nevertheless, the description is detailed enough for us to imagine the drawing in which "a standing woman, of middle age, neither completely clothed nor unclothed, so that she is halfway between Riches and Poverty, bound by her left foot in order to minimize the offence to her more noble parts, it being in her power with her free hands to unchain herself and leave her post. We have attached the chain to the stone; and she, courteous, with her arms makes it known that she does not wish to leave until time, with dripping water, consumes the stone to which she is chained: drop by drop, water drips from the hourglass, the timekeeper of antiquity, used by orators when declaiming. Thus, she hunches her shoulders, staring fixedly at the stone to gauge how long she will have to wait before the hard stone is worn away; she suffers and waits with that hope sorely experienced by those who endure distress in order to accomplish their design with patience. It seems to me that the motto is very appropriate and fitting on the stone: *Diuturna tollerantia*".[7]

In a letter dated 28 November 1551, Minerbetti sings the praises of the drawing received from Vasari a few days earlier, revealing that the painting was to be executed on a canvas measuring three *braccia* (175 cm), and, then, lavishing florid praise on the invention, he writes to the painter that, given the beauty of the conception, he would be happy even if the painting were to be executed by one of Vasari's young pupils. "I returned here on Monday, when I found my Patience by your hand, so well drawn that one sees that she is truly suffering; and if I found [someone] to paint her for me, so alive, on a canvas of three *braccia*, I would be as satisfied."

In order to flatter Vasari, Minerbetti continues: "I shall look for someone who will prove satisfactory, if it is possible to find someone here, and, should I fail, you will find me before you once again, so that you may find someone who can put her *on canvas* for me".[8] His offer to find another artist to translate Vasari's invention into paint should be read as a rhetorical courtesy magnifying a project that it would in reality be

impossible to entrust to somebody else, and indeed Minerbetti already promises Vasari that, should an able youngster not be found, he will come back to confront Vasari himself. Finally, he asks Vasari to thank Michelangelo and Annibale Caro, who "have employed their genius (*ingegno*) for such a lowly thing, and you, your genius and the labour of your hand". In the light of later documentation, the suggestion that the work be painted by another artist seems to have had as its objective to goad Vasari into executing the allegory himself, and the wishes of such an important patron as the bishop of the artist's native city must have been fulfilled, at least as far as one can judge from all the later letters and records relating to the painting.[9]

Re-reading the correspondence as a whole, we come to realise how difficult it would have been for Minerbetti to accept a work conceived by Vasari and then executed by a pupil, as his intention was that the composition should be conceived by Michelangelo, then be executed by Vasari. Such a wish was clearly expressed in a letter dated 4 October 1551: "… and, as I am unfortunately not able to have something by his hand [Michelangelo], he has at least allowed me, through his goodness, to enjoy something from his infinite genius according to my fancy , and it is this. Let him tell you how he thinks that Patience should be painted. As I told you, Patience is my emblem, which I adopted when I was a youth in the service of my uncle, so bizarre and malicious (*arabico*); in addition to the countless lowly services that I had to perform, I also had to endure endless insults. So that, recognizing that I was poor and abandoned, I resolved that Patience should guide me to this [my present] rank, which – with thanks to Jesus I hold with great contentment."[10] In another letter to Vasari, dated 31 October 1551, the bishop had written that he was anxiously awaiting Michelangelo's invention, executed by Vasari: "It is with great longing that I wait for Patience, shaped by your blessed hands and devised (*ghiribizzata*) by that grand old man whom everybody admires and rightly honours".[11] Once painted, the work would have been the perfect counterpart to the *Venus and Cupid* executed by Pontormo for Bartolomeo Bettini from a design by Michelangelo: unable to acquire a work by the hand of the divine master, both patrons had been content to own one of his inventions put into the hands of a painter dear to him. Minerbetti's intentions were to have the allegory installed "in an oval (*in un ovato*)" beneath a lunette with a figure of Minerva, alluding to his

family name, whilst above the window, in another lunette, there was to be a representation of Mercury "flying off into the sky" (*che se ne vola al cielo*).[12]

From the correspondence, we know that the *Allegory of Patience* was placed in a ground-floor room of the Florentine residence of the Bishop of Arezzo, the *grottesche* decoration of which had been executed by Giovanni Capassini,[13] although the project was never brought to completion. It was Minerbetti's idea that the canvas should have as a pendant an *Allegory of Contentment (Contentezza)*, which Vasari may never have painted, but which was nevertheless promised in a letter written to the bishop from Rome some time between April and June 1553.[14] The painting would have been placed in that "old ground-floor room" where "the Patience *that I sent you* glows", "as will also [glow]"[15] the *Contentment (Contentezza)*. Vasari assures him that "without sending you another drawing, she will be painted by me sitting, full of gladness, in a restful attitude, crowned with laurel, roses, olive [branches] and palms, among myrtle and flowers, looking up at the sky in divine contemplation." There follows a long list of symbolic elements which seem more like a mass of ideas than a specific iconographic project, as Vasari himself makes clear: "I speak here without aforethought (*improvisamente*), more to give a satisfactory response to your letter than as a plan for the work that I will paint".[16] Although we do not have a letter by Vasari corresponding to the consignment of the *Patience*, in one relating to the second allegory he declares the autograph nature ("I sent you") of the canvas glowing in Minerbetti's Florentine palace. As further proof, in the same letter the painter asks the patron to send him also the "measurements of the space (*vano*), so that this would correspond to the *Patience*", to which he receives the following reply on 17 June 1553: "this painting is 4 braccia by 2 in width (*questo quadro è 4 braccia e largo 2*)". The measurements of the space in which the painting was to hang, evidently together with its frame, confirm to us that the work delivered was slightly larger than the three *braccia* referred to in the letter of intent.[17] Further evidence that *Contentment* was to be painted as a pendant to the of *Patience* is found in another letter to Vasari, dated 1 July 1553, in which Minerbetti proposes to send the support requested by the artist directly from Florence to Rome; taking into account its size, the bishop adds a note in order to remind him that "such a wide canvas cannot be found; one needs to have a damask-weave cloth".[18]

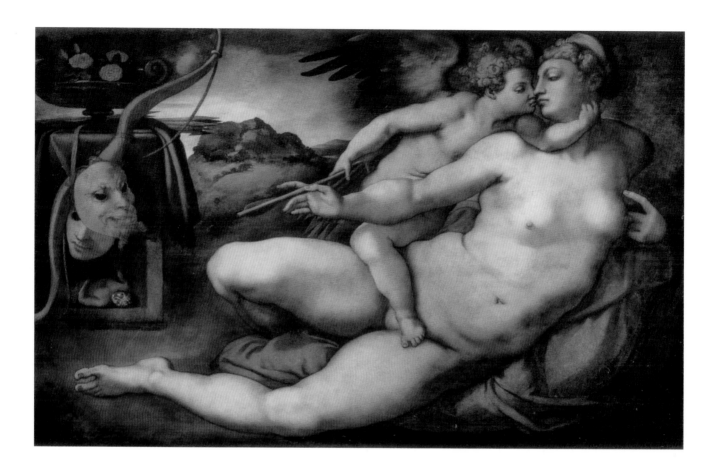

Events only seem to become more complex when the emissaries of Ercole II d'Este, Duke of Ferrara, appear on the scene. At a dinner held in Minerbetti's residence referred to in a letter dated 7 January 1553 – Benedetto Varchi, the Cardinal of Ferrara, Ippolito II d'Este and his secretary Marcantonio Falconi, Bishop of Cariati, were present – there were long discussions as to how one might paint an allegory of Patience. Benedetto Varchi gave proof of his erudition in a speech on the subject of that state of mind, and reminded the company that, as far as he was aware, there were no representations of it known from Antiquity. Ippolito II d'Este described the different inventions which had been conceived to date, and revealed that he had been seeking the opinion of all the best men of letters on this subject, because the Duke of Ferrara,

4
Pontormo
Venus and Cupid
Oil on canvas, 128 × 197 cm
Florence, Galleria dell'Accademia

having chosen Patience as his *impresa*, wished to have "representations of it among his things (*figurarla nelle cose sue*)".[19] In the letter, Minerbetti reveals to Vasari that up to that point he had listened to all the different arguments without uttering a word, but once "he had seen that none of the ones described came anywhere near yours", he decided to describe the painting, "and then show your drawing together with your letter, which I always carry on me with the drawing. At this point wonder was born, and the desire to possess it [the drawing]: I could not but acquiesce to the request, as they were asking in order to send it to the Duke".[20] The following day Minerbetti (from the letter we can deduce that he had not shown the painting, but only the description and the *modello* on paper), had "a skilful youngster (*un buono giovane*)"[21] make a copy of the drawing, delivering this to the Duke's emissaries, who then left for Siena.[22] A few days after this dinner the bishop must have received from them a further request regarding the *Patience*. We do not have the letter, but it is likely that the request to Minerbetti was for something more than a copy of the work, as can be deduced from the heartfelt and suggestive entreaty to Vasari to come immediately to Florence from Arezzo, where he was at the time. From the response, we know that Minerbetti had flatly refused the new request ("which I shamelessly refused"),[23] inventing the excuse that he had requested Vasari for the design for new vestments (*paramenti*), and was therefore not in a position to be able to request anything further from him until this commission had been fulfilled. This story, which is recounted to the artist in excited language, appears to have been invented in order to prevent the possibility of a pressing request from Ippolito II d'Este, who perhaps was not content to simply have a copy of the drawing, but was planning to lay his hands on Vasari's painting. In the letter, Minerbetti almost orders Vasari: "you will come here, and indeed we will reflect on the design for the textiles [*panni*] and for other things, so that I, who have such great regard for you and such admiration for your works, will not be deprived of the twenty brushstrokes I have of yours in my home".[24] Evidently, Minerbetti feared that the Duke of Ferrara might have entreated him for the autograph painting of *Patience* ("brushstrokes I have of yours in my home") as a model, and the bishop was looking for a way out, involving Vasari in the process. In any case, the letter is confirmation of Vasari's authorship of the painting representing *Patience*, as well as the bishop's attachment to the work which he had coveted for

so long. As has been observed by Alessandra Pattanaro, on 10 June 1553 the bishop had another sketch made "from that initial drawing (*da quel primo disegno*)" in order to correct the tapestry executed by the "weaver of Saint Mark's (*l'arazzier di San Marco*)" for Duke Ercole II, in which, in a cameo, a figure of Patience deriving from Vasari's invention appears, but "poorly composed" (*mal composta*).[25] Finally, in another letter to Vasari of 24 June 1553, the bishop reminds the painter that he had had a third sketch made "from his work" (*dalla vostra opera*), as Duke Ercole had also expressed the wish to see in colour: "and I have had it copied in tempera by a skilful young man and will send it to him today".[26] As well as providing further proof of the existence of an autograph version of the painting by Vasari, the sequence of letters reveals that during the dinner with the emissaries of the Duke of Ferrara Minerbetti had shown only the drawing for the project and Vasari's letter containing the description, and not the actual painting, which he had jealously kept hidden. The first replicas of *Patience* to reach Ferrara were therefore based on the drawing, in which there appeared all the different attributes of the figure as described in the letter – clock, motto and chain. The only work deriving from Vasari's painting was the third and final sketch – executed in tempera to capture its chromatic aspects – which the bishop promised to send to the Este court in a letter of 24 June 1553.

Further proof of the existence of the canvas painted by Vasari is to be found in a later letter, written in 1565 by Minerbetti again to Vasari, in which he recalls the work in jocular fashion by means of a proverb: "a man who has patience, as I have always had and will have as long as I live, *thanks to you who painted it for me so beautifully*, eats thrushes at a penny each".[27] Vasari would refer to the autograph nature of the canvas, in which the figure of *Patience* is represented life-size, on two subsequent occasions. In his autobiography he wrote: "... having therefore moved to Arezzo, to go from there to Florence, I was required to make for Monsignor Minerbetti, bishop of that city, as my lord and great friend, Patience, in a life-size picture, in such a manner that [this figure] was then used by Ercole Duke of Ferrara as his emblem and on the reverse of his medal. Having completed the work, I came to kiss the hand of Duke Cosimo, who was good enough to see me with great pleasure."[28] According to the autobiography, Vasari had painted the work in Arezzo, and then delivered it in person taking advantage of a journey to Florence, where he met Duke

Cosimo. Vasari's passage matches one in the *Ricordanze*, in which the artist also notes the sum received in payment: "I remember that I painted a figure representing Patience on canvas, life-size, for Messer Bernardetto Bishop of Arezzo, for which I received 15 *braccia* of red satin, which he presented to Madonna Cosina my lady; it was worth twenty *scudi*".[29]

In the light of the many testimonies relating to Vasari's authorship of the Patience, we should now reconsider the letter which led to the attribution of the execution of the Pitti canvas to Becerra. In the letter we have already referred to, dated 5 May 1552, sent to Vasari "in Arezzo" (the city in which he himself recalled having executed the painting), Minerbetti writes that "Becerra removed a certain number of specks (*bruscoli*), which had fallen and stuck to that *Madonna della Costanza*, and, this evening, I believe he will arrange (*acconciare*) the Patience, and he has heaped praises on everything".[30] The young man had come to Florence in order to clean a *Virgin* painted by Vasari for a certain Costanza[31] on which some particles of grime had stuck – in other words to carry out a restoration. Then, as Minerbetti writes, "this evening" the young man "will arrange (*acconcierà*) the *Patience*" – a quick job, completed in a brief space of time, and at night. This is not consistent either with his executing the entire work or with his completing a work begun elsewhere, as evening was certainly not a suitable time of day for painting. Furthermore, in the first edition of the *Vocabolario della Crusca*, the word "*acconciare*" never has the meaning of 'painting', signifying rather restoring, that is arranging, putting back in order, fixing something. If the work undertaken by Bacerra took so little time that it could be completed in the space of an evening, but was worth reporting to Vasari as it involved the *Patience*, it may have involved the definitive fitting of the painting executed by Vasari into the frame planned for it. Becerra had probably come to Minerbetti's residence in order to work on two of Vasari's paintings, the one to be cleaned of dirt and the other to be fitted into its frame. It is only by reading the letter in this light that the bishop's final comment to Vasari regarding the opinion expressed by the young man makes sense: faced with two works by his own master, he "heaped praises on everything".[32] Becerra therefore expressed to the bishop his own admiration for both the paintings which he had been called to work on, and he certainly could not have praised "everything" if *Patience* had been his own work, even if painted after a design by Vasari.

Vasari's autograph work

The *Allegory of Patience* painted by Giorgio Vasari for Bishop Minerbetti, a compelling design of great power, demands to be regarded as one of the Aretine artist's absolute masterpieces. The painting measures 197.8 × 108.8 cm, a little larger than the canvas which hangs in Palazzo Pitti, at 177 × 101 cm, and than the canvas hanging today in the Galleria Nazionale in Modena, which is of a slightly more rectangular format (186 × 97 cm), and ascribed to Camillo and Sebastiano (called Bastianino) Filippi. Although the measurements of the two previously known paintings are comparable to those recorded in Vasari's project (3 *braccia*, or 175 cm), we should bear in mind that the space reserved for the painting representing *Patience* measured by Minerbetti in order to commission from Vasari a pendant of the same size was 4 by 2 *braccia* (233 × 117 cm). Quite apart from the style, the size of the present canvas seems to fit better with the dimensions of the work which dominated that "ground-floor room (*stanzaccia terrena*)" in *casa* Minerbetti, assuming the bishop had sent Vasari the dimensions of the whole oval-shaped space, taking into account the frame and the original stretcher, which are now lost.[33] As the space was "oval (*ovato*)" in shape, the original frame would have linked together the oval with the rectangular shape of a painting which nevertheless was twice as tall as it was wide.

The autograph status of the present version, having now been established, permits us to provide a new sequence for the series of replicas and derivations from it, which form two distinct groups – the first of faithful copies, to which there belong all the Florentine paintings with the exception of the work in Modena, and the second of derivative works based on the original model but displaying significant variations, to which belong the versions in Ferrara. These are bearers of additional meanings attuned to courtly culture and absent from the prototype executed for a bishop.

As we have shown, the evidence for Vasari's authorship of this canvas renders superfluous any of those detailed comparisons that are customary practice when attributing a work. One only has to observe the monumental design of the female body and the sharp, broken folds of the drapery (painted with colours that range from a deep purple to pink,

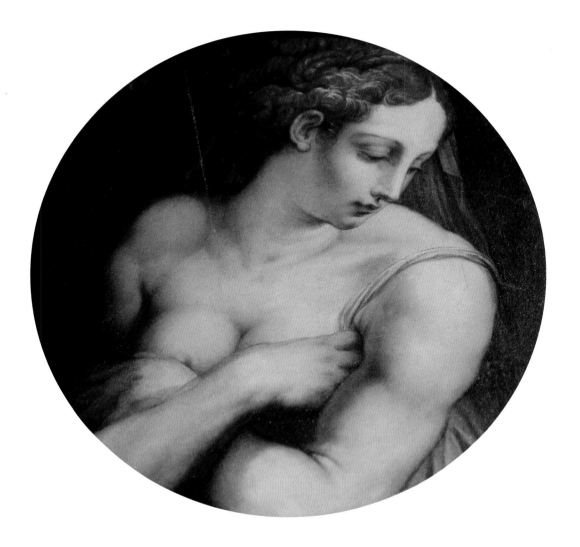

and then to blue, resulting in a sober *cangiantismo*), to recognize features of Vasari's best paintings, which in this work are bolstered, unusually, by stylistic elements which are purely characteristic of Michelangelo, who had conceived the figure. Finally, one need only compare the features of the woman with the faces of the female figures by Vasari in the panel paintings dating from the 1550s and 1560s in order to identify, beyond all doubt, the author of this powerful work. As a sole example, it will suffice to mention the partial replica of the upper section of the figure – down to the arms held close to the body – which Vasari painted around 1563 in one of the *tondi* of the altarpiece of the Badia of Sante Flora e Lucilla (fig. 5).

5
Giorgio Vasari
Allegory of Chastity
Oil on canvas
Arezzo, Badia delle Sante
Flora e Lucilla

The iconography, the Florentine replicas, the Emilian variants

Over and above Vasari's authorship, in order the better to understand the fortune enjoyed by the original painting we will devote some attention to the series of copies and derivations of the *Patience*, both Florentine and those in Emilia. As Vasari's prototype has until now been identified with the painting in Palazzo Pitti, in which the figure is bare-breasted and draped *all'antica*, scholars have been unable to explain the absence in other Florentine works of formal elements deriving specifically from this work – a very odd occurrence, had this indeed been the Minerbetti painting, as the most faithful derivative works are instead those in Ferrara, for instance the medal struck by Pompeo Leoni for Ercole II d'Este.

The best-known and earliest Florentine derivation, the drawing in the Louvre attributed to Tommaso Manzuoli da San Friano (known as Maso da San Friano) with the motto *diuturna tolerantia* (fig. 6), seemed to scholars, as a result, to be a variant of the presumed prototype in the Palazzo Pitti, on a par with the canvas in the Galleria Nazionale in Modena (fig. 7): in both these paintings the figure modestly covers her breasts.[34] This reading, however, could not account for the existence of two variations of the same subject, one associated exclusively with Ferrara, that of a bare-breasted figure (among the Ferrara works it is only in the painting by Camillo and Bastianino Filippi that the figure has covered breasts), and one almost entirely Florentine, in which the figure chastely covers her breasts, her arms held tightly against her body, since the presumed prototype for the whole series in the Palazzo Pitti is bare-breasted.

With the rediscovery of Vasari's original painting of *Patience*, it becomes possible to place the different elements of the puzzle correctly, each in its proper position. The Modena canvas and the Louvre drawing, in which the chaste pose of the figure is identical, immediately stand out as the most faithful replicas of the original models, which were two in number – the drawing sent by Vasari together with the letter of 14 November 1551, and the canvas which has finally come to light. A copy of the former with the chain that imprisoned the woman had been sent to the Duke of Ferrara by way of his emissaries, and would be replicated several

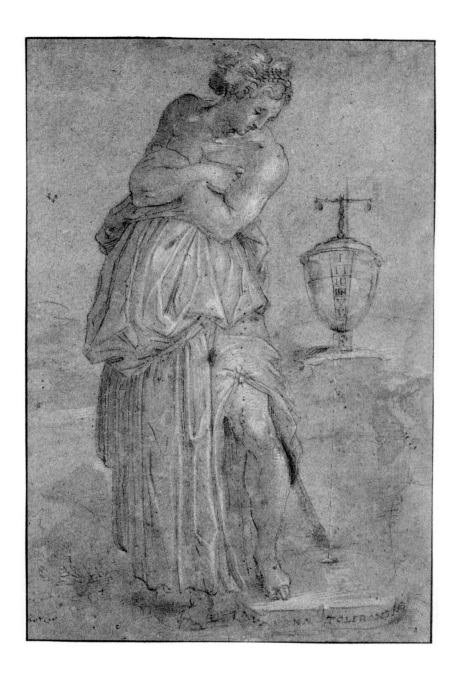

6

Attr. Tommaso Manzuoli,
called Maso da San Friano
Allegory of Patience
Pen and brown ink, brown wash, over
black chalk, with white highlights,
on grey-blue paper, 266 × 175 mm
Paris, Musée du Louvre, Département
des Arts graphiques, inv. 1660

7
Camillo and Bastianino Filippi
Allegory of Patience
Oil on canvas, 186 × 97 cm
Modena, Galleria Estense

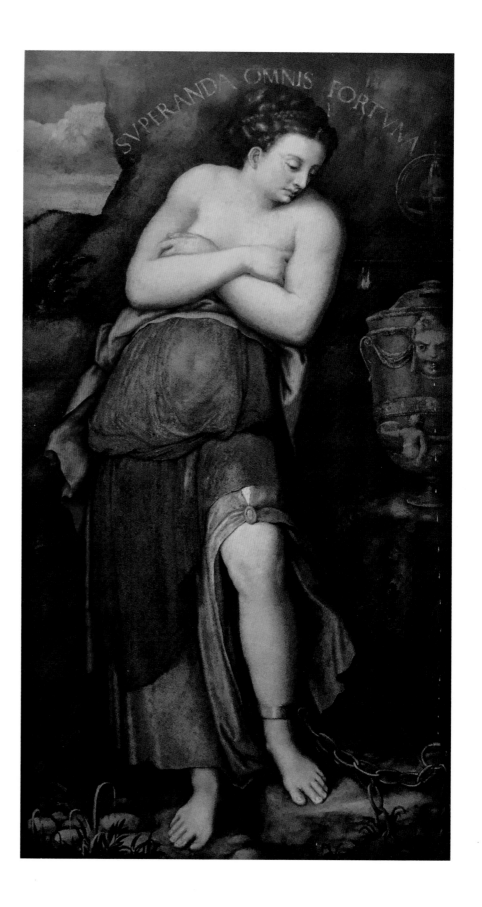

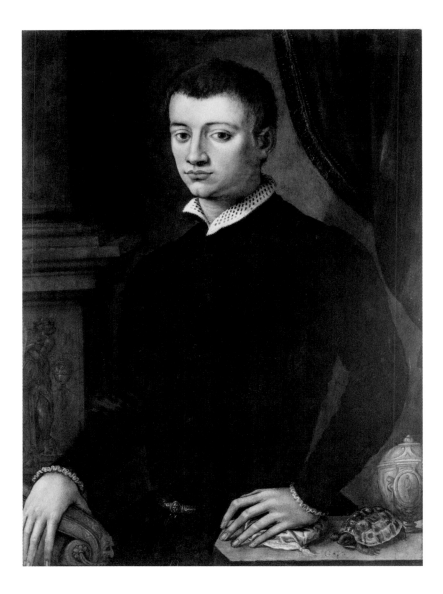

8

Attr. (formerly) Giorgio Vasari
Portrait of a young man
Oil on panel, 86.3 × 63.5 cm
Sold Christie's, London, 31 October
1989, lot 86; present whereabouts
untraced

times with that attribute; the second prototype – the painting we present
here – had instead not been shown to the Duke's emissaries and it differed
from the drawing in that the chain was no longer present, substituted by
the motto conceived by Annibale Caro for Minerbetti (*diuturna tolerantia*).
Although sharing the same pose, the two figures, in the Modena painting
by Camillo Filippi and in the Louvre drawing, differ in their attributes
precisely because the former derives from the Vasari drawing and has

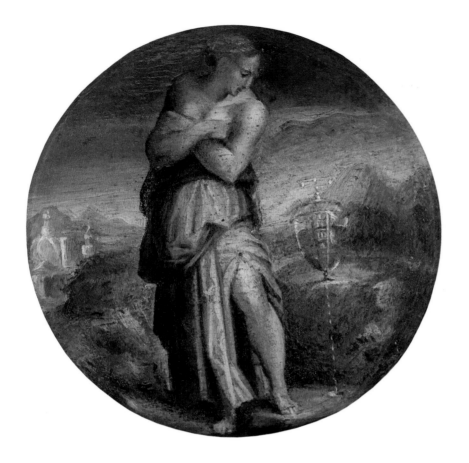

9
Giorgio Vasari
Allegory of Patience
Oil on panel, diam. 10 cm
Private collection

the chain and the latter derives from Vasari's painting and does not have the chain, but has the motto inscribed on the stone on which the woman rests her foot. This motto is absent in the Ferrarese works as it could only be used by the bishop for whom it had been conceived. To these replicas in which the woman crosses her arms over her breasts should be added two other equally faithful ones: the first is painted in the background of a portrait that scholars attribute to Vasari himself,[35] in which, on the right, on the base of a column, a grisaille reproduces Vasari's painting; the second replica is instead a small unpublished *tondo,* painted on panel, in which the figure is like that in Vasari's painting, with the addition of a view of Florence in the background (fig. 9).[36]

 With the Minerbetti *Patience* before us, the chronology of the series of derivative works can now be turned on its head and, as a result, we

are able to reconstruct a different sequence of events for the reception of Vasari's painting both in Florence and in Ferrara. By comparing the symbolic attributes of the figure, it will finally be possible, further, to distinguish the derivations which have the Minerbetti canvas as their model from those – especially in Ferrara – which were instead based on Vasari's projected composition, sent in a letter to the patron and copied in its entirety for the ambassadors of the Duke of Ferrara who, we reiterate, never saw the painting. With the recovery of the prototype, we are able to understand the reasons behind the principal iconographical anomaly in some of the early Florentine replicas, in which the chain binding the figure of Patience is missing – in contrast to the Pitti canvas and the painting in Modena, in which the attribute is present in conformity with Vasari's programme as shown to the emissaries of the Duke of Ferrara. The attribute of the chain, described in Vasari's letter and also present in the drawing which is now lost, is always present in the versions executed for Ercole II d'Este, but is instead absent from all other versions of the same allegory painted by Vasari himself, even when part of different compositions, and the chain is also absent from contemporary Florentine replicas of the painting which are faithful to the original, based on Michelangelo's *invenzione*.[37]

As to the pose and the attributes, in the letter with the programme for the composition, Giorgio Vasari describes "a standing woman, of middle-age", represented "neither completely clothed, nor unclothed, so that she is halfway between Riches and Poverty". Her arms are clutched to her breast, as "she hunches her shoulders" and stares "fixedly at the stone [to guage] how long she will have to wait for the hard stone to be worn away" as water drips on the stone from an "hourglass, the timekeeper of antiquity, used by orators when declaiming".[38] In the Minerbetti painting, the woman places her left foot, free from chains and bare to a little above the knee, on a stone step on which is engraved the motto *diuturna tolerantia*. No such motto appears on the canvas in the Galleria Palatina of the Palazzo Pitti, the painting until now considered to be Vasari's original, executed by Becerra. The motto, conceived by Annibale Caro specifically for the bishop of Arezzo, signifies how Patience will "suffer and waits with that hope sorely experienced by those who endure distress, in order to accomplish their design with patience".[39] As scholars have observed, the motto refers to a phrase in Cicero's *De inventione* (II, 54, 163-164)

"*Patientia est honestatis aut utilitatis causa rerum arduarum ac difficilium voluntaria ac diuturna perpessio*",[40] where Cicero insists on the element of voluntary forbearance (*perpessio*). Nevertheless, despite the reference to the free will involved in achieving the state of mind of one who is patient, in the project sent by Vasari to Minerbetti the figure of Patience is described as chained to a stone, while the "*gutta cavat lapidem*". In Vasari's idea, in order to express the voluntary aspect of Patience's wait, it was sufficient to represent her with her arms free, but crossed, as if to proclaim the will not to free herself from the chain, but rather to wait for the dripping water to wear away the stone to which the chain was attached.

Between the project and its realisation, further arguments must have been taken into consideration which were probably entrusted to letters which have not reached us. There were perhaps reflections involving the voluntary aspect of endurance, as reaffirmed by Minerbetti in a letter of 1551.[41] As the chain is a symbol of imprisonment, its presence might have clashed with the concept of a deliberately chosen and patiently endured wait, as expressed by the Ciceronian motto. Other representations of *Patience* painted by Vasari provide evidence for the various options chosen in relation to the project, all of them being free of that instrument of constraint, as is also the case with the majority of the early Florentine derivations from Minerbetti's painting. In contrast, the chain appears in all the Ferrarese versions, as these, as we have already observed, derive from the drawings copied not from Vasari's painting but from the letter and the project for the composition that Minerbetti had copied and haned over to the emissaries of Duke Ercole II d'Este. Both the drawing and the letter contained the motto (*diuturna tol[l]erantia*) as also the chain, as if to represent different and alternative iconographic options. However, as Annibal Caro's words had been devised specifically for Minerbetti, these could not be used by others. In the painting that scholars have identified with the one painted for the room of Patience in the castle of Ferrara (which now hangs in Modena), Caro's words were substituted with a different motto in line with the thinking of Duke Ercole II (*superanda omnis fortuna*), while the chain was retained in deference to Vasari's model, as described in the letter to Minerbetti and represented in the drawing.

That the problem of the chain was central to the subject matter, and that its presence or absence at the feet of Patience was something probably discussed at some length at the time of its execution, can be understood

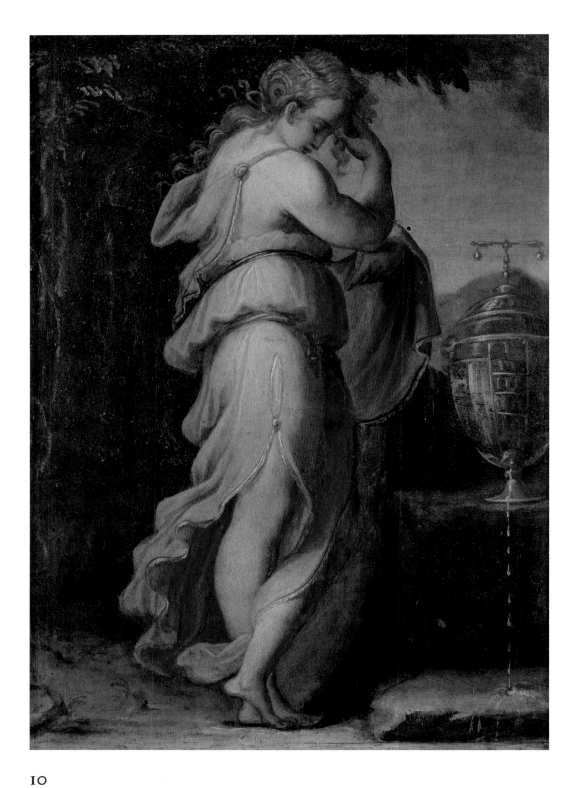

IO

Attr. (formerly) Giorgio Vasari
Allegory of Patience
Oil on board, 35 × 24.5 cm
Florence, Galleria degli Uffizi

from a few manuscript pages by Pirro Ligorio that have previously been linked with the Ferrarese versions of the *Patience* by Carmelo Occhipinti. Ligorio – in the service of Cardinal Ippolito II d'Este – was in Rome in the 1550s, as was also Vasari, and in those pages, although written at a later date, he recalls that at the time he had proposed his own version of the allegory of Patience, a version that was not adopted by the Duke, who had preferred Vasari's version for Minerbetti. In contrast to the latter, the Patience conceived by Pirro Ligorio "must not be tied, but free and unbound and strong in spirit, and of a prudent and perspicacious mind, and constant in the face of all persecution".[42] If we bear in mind that in Vasari's letter to Minerbetti there had also been insistence on the presence of will, so that the *diuturna tolerantia* should be the result of the exercise of *virtù*, we can surmise that Ligorio's alternative was not simply the fruit of his anti-Michelangelesque stance, but also of arguments evolved in Rome which in his opinion demonstrated that in Ferrara certain elements of the allegory had not been understood. This reasoning was indeed probably shared by Michelangelo and also by Vasari, as the latter would omit the chain in his subsequent paintings. Moreover, Michelangelo was notoriously averse to the use of symbolic elements in his works: one need only remember that, of the four figures in the New Sacristy, only that of Night bears recognizable symbols, whilst the other figures are free from any attribute.

The drawing and the letter with the description which Vasari sent the Bishop of Arezzo therefore contained only an initial idea for the figure, and in it were listed some of the possible attributes, in a fashion similar to the following missive regarding the *Allegory of Contentment*, in which Vasari also described a great number of possible symbols which would be suitable for the subject matter. In the case of the figure of *Contentment*, Vasari had not discussed the invention with Michelangelo, but had implemented his own specific method of interpreting the allegory, constructing the image with such a great number of symbols that it would have been difficult to represent them all in a painting: he would subsequently have chosen the most appropriate during the execution of the work.[43]

To summarize, it is likely that, when the time came to execute the work, the motto and the chain appeared incompatible with one another, Annibal Caro's words exalting the will-power required by Patience, whilst the

chain would have indicated the constraint involved. In the work delivered to Minerbetti which has now resurfaced, Vasari retained only the words of Ciceronian inspiration dedicated to the bishop, words that were also retained in the Louvre drawing, which therefore becomes the closest and most faithful sixteenth-century testimony of the painting we publish here. In the drawing, attributed to Maso da San Friano by Alessandro Cecchi,[44] it is precisely Vasari's painting and not the drawing of the project which is portrayed, as, in addition to representing the figure of Patience with no chain and in exactly the same pose as in Vasari's painting, the drawing is the only derivation to place the motto *diuturna tolerantia* precisely in the same position, that is, on the step on which the woman rests her foot.

In accordance with the prototype, the chain is absent in all the early Florentine copies that faithfully reproduce the pose of the Minerbetti *Patience*, as also in the different formal variants of the same subject executed by Vasari or by artists of his inner circle.[45] The small *tondo* painted on panel which we present here (fig. 9) also derives from the prototype on canvas. In this work, Patience is in the same pose and has the same mighty proportions as Vasari's figure, and the chain is also absent, but the figure is set in a landscape in which one perceives the cupola of Santa Maria del Fiore in the background, as though to reaffirm the link with the city. Annibal Caro's motto, however, is not present in the *tondo* because, as we have observed above, this iconographic element was linked solely to Minerbetti. The cameo does not therefore seem to have been executed for the bishop, but for another Florentine patron whose identity remains unknown. However, if at first glance the work seems to derive from the Louvre drawing, the monumentality of the figure, and the less elongated proportions of its anatomy as well as the sharply defined folds of the drapery, suggest that this small *tondo* was also executed by Vasari rather than by Maso da San Friano. The chain is also absent from a *Patience* painted in a *bozzetto* on panel in the Uffizi once attributed to Vasari (fig. 10).[46] The woman is represented with a meditative expression and in profile, by the side of a water clock of simplified shape, as in all of the sixteenth-century Florentine versions referred to above. However, the absence of the motto and the free and flowing folds of the tunic, never fractured or metallic as are those painted by Vasari, may indicate that the *bozzetto* was executed by an artist from Vasari's circle in the 1560s, for an unknown patron. And finally, also represented without a

chain, there is the *Patience* painted by Vasari himself, after 1563, as one of the requisite virtues of Duke *Cosimo engaged in studying the taking of Siena* (*Cosimo impegnato a studiare la presa di Siena*), on the ceiling of the Salone dei Cinquecento (fig. 11). This time the woman is represented entirely enveloped in the ample folds of a garment, by the side again of a water clock of the plainest design, devoid of any decoration. In addition to the absence of the chain, and in line with Vasari's prototype, another common characteristic of the early Florentine derivations is the simplicity of the antique time-piece (*oriuolo antico*)[47] – a crystal or metal vase plain in shape and ornament, only incised with the hours, its outline barely interrupted by the presence of small decorative masks. In contrast, in all of the derivations in Ferrara, the same object is represented according to the decorative taste of the Este court, abounding in delicately highlit masks, figures and foliage in gilded bronze (figs. 12, 13, 14 and 15).

Having recovered the prototype executed by Vasari, it also becomes much easier to organize the versions in Emilia into a chronological sequence, beginning with the observation that the chain is always present in every representation of the *Patience* executed for the court at Ferrara. Besides the record of the lost cameo inserted into a tapestry, which we know had as its model the first drawing delivered by Minerbetti to Ippolito II d'Este,[48] the earliest known Ferrarese derivation seems to be a canvas which now hangs in the Galleria Estense in Modena that has been rightly attributed to Camillo and Bastianino Filippi.[49] The work is in fact the only large-scale replica in which the figure is faithful to Vasari's prototype, both in the pose of the figure and in the modesty of the gesture with which she covers her breasts. She seems therefore to have been the first to have been executed from the copies of Vasari's drawing sent to Ferrara by the emissaries of the Duke. Scholars have identified the painting with that executed for the Duke of Ferrara's residence, in which the painting representing Patience is recorded in a document dated 23 June 1554, when the work hung in the "Camarone Novo in Castello".[50] Camillo Filippi himself was paid for having "arranged" it (*conzata*), that is adjusted, restored it, perhaps as a result of the damage incurred during the fire that had broken out in the castle in February 1554.[51] In addition to any restoration, the "*conzata*", that is the "arranging" that the painter had carried out, may also indicate that the painter had simply fitted the painting into its frame, as another contemporary document records a

payment for the scaffolding raised in order to hang a painting of *Patience* in the Camera "del revelin", which only later would become the Camera della Pazienza, taking the name of the painting.[52] Alessandra Pattanaro's hypothesis that the *Patience* now in Modena was executed for the ceiling of the room and not for one of the walls seems therefore to be supported by the concordance of the two records relating to the painter's intervention and to the scaffold. Nevertheless, the sequence of documents does raise a number of questions with regard to the time taken to install the work, unusually long for a medium-sized painting. A subsequent intervention, undoubtedly carried out on the painting now in Modena, is documented on 20 April 1555, when Girolamo Bonaccioli was paid for painting the inscription in capital letters around the figure, but only on 15 June of that same year was he paid for making a frame of walnut for "the portrait of Patience (*il Retratto della Patientia*)",[53] without specifying in which room the work was to take place. This is a rather unusual progression for a painting which must have been installed in the Camera della Pazienza for over a year, after the raising of a wooden structure half the height of a fort. It is also curious that the letters of the motto were added only after the installation of the work in the ceiling rather than before, and finally, that the frame was not immediately fitted once the scaffold had been put into place for the installation of the painting in the Camera della Pazienza. In short, the installation of the *Patience* lasted from June 1554 to June 1555, and was carried out in three different moments in time, a time-scale which seems excessive for a single, medium-sized work. Furthermore, one should take into account the fact that the payment record which relates to the fitting of the "*Retratto della Patientia*" into a walnut frame in 1555 does not refer to the room of that name, while the 'Room of the Patience' is indicated for the other work carried out in proximity.[54] Finally, one must bear in mind that, on 18 April 1556, Camillo Filippi was paid for having gilded the ceiling of the Camera della Patienza but also for having painted a "pendant inserted into the middle of the vault in the room next to the Camera della Pazienza in the Tower of Saint Catherine (*paralello fondato quale è in mezzo la volta della camara apresso la Camara della pacientia nella Tore di Santa Caterina*)". Alessandra Pattanaro has asserted that the record refers "unequivocally [to] a ceiling painting, parallel to a pendant painted in the neighbouring room, (that is that of Patience), stretched and framed".[55]

II

Giorgio Vasari and Giovanni
Stradano (Jan van der Straet)
*Cosimo I de' Medici planning the
Siege of Siena*
Oil on panel
Florence, Palazzo Vecchio

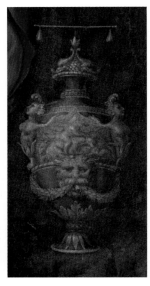

We therefore have to ask ourselves whether the paintings representing Patience deriving to a greater or lesser extent from Vasari's model and executed for Ercole II d'Este were two, and not just one, as scholarship has supposed hitherto, ascribing the painting in Palazzo Pitti to an artist in Vasari's circle. The arrangement of the various rooms of the Este castle included – among the representations of the various allegories of the virtues that the Duke had commissioned – two representations of Opportunity (*Occasione*) [56]. Nothing is more likely, therefore, than that he should also have had more than one painting of *Patience*, emblem of Ercole II. The first, more faithful to Vasari's prototype – the painting in Modena – with the motto alluding to fortune, could have been associated with one of the representations of Opportunity, whilst a second and autonomous painting was to be inserted into the ceiling of the Camera della Pazienza. Unfortunately, the documents relating to the castle under Ercole II do not allow us to reconstruct the precise disposition of the various paintings of allegorical subjects which are now dispersed in various museums and collections as a result of alterations dating back to the sixteenth century. [57]

In contrast, we can be more precise with regard to the compositional evolution of the different Ferrarese representations of Patience based on

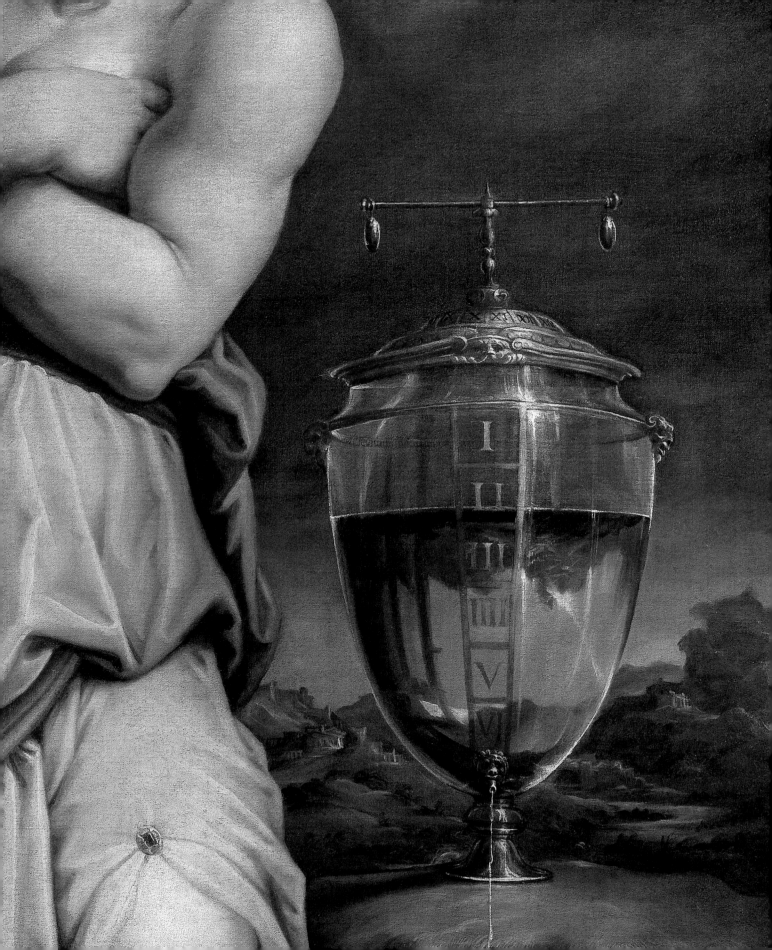

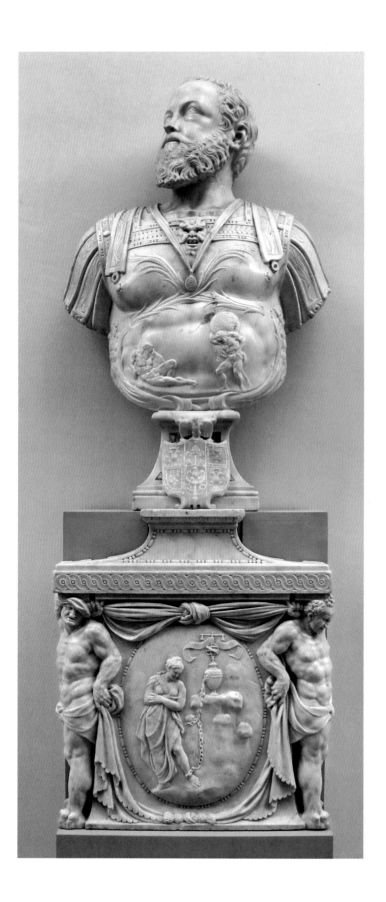

16

Prospero Sogari Spani
Bust of Ercole II d'Este
Marble, the bust 110 × 75 × 40 cm
Modena, Palazzo dei Musei

the painting now in Modena, which documents indicate was the first to be executed for Ercole II. The painting, in which the figure is faithfully based on the drawings sent from Florence, linked to the intervention – possibly a restoration – carried out by Camillo Filippi on 23 June 1554, might already have been painted in 1553, before the fire of February 1554. In fact, the figure painted by Camillo and Bastianino Filippi, although replicating precisely the pose in Vasari's painting – with the addition of the chain derived from the project drawing – already displays a number of features adapted to the decorative style dear to the Este court. The water clock is no longer an amphora with simple and plain outlines, but has acquired masks, festoons and figures in gilded bronze, and most importantly is topped by an armillary sphere, as is the case with all the versions executed for the court of Ercole II d'Este. In subsequent documented Ferrara versions of the *Patience*, the pose and gestures of the figure will be altered, moderating its modesty, an element which in Vasari's model befitted the religious and ethical values of Minerbetti who was, after all, a man of the Church. In the Ferrara paintings on the other hand, the clothing and gestures of the female figure are charged with a sensuality attuned to the court that had cherished the nudes of Titian and Dosso Dossi. We find the earliest example of this in the base of the bust of Ercole II d'Este (fig. 16), sculpted by Prospero Sogari Spani in 1554, that is at the time of the restoration of the Modena *Patience*. In the bas-relief on the pedestal of the bust, the woman no longer has her arms crossed, her hands clutched beneath her armpits, but reveals one breast, and wears a thin garment which adheres to her naked body and reveals its shape. Again with a provenance from Emilia, and probably by the hand of Girolamo Mazzola Bedoli, is an unknown drawing which we publish here (fig. 17), in which Patience, again chained, is represented with crossed arms, but her sensuous body is revealed through the clinging diaphanous drapery associated with the paintings of Parma; and she reveals her breasts in homage to a courtly taste which was open to representations of explicit sensuality. The same occurs in the medal executed by Pompeo Leoni, again in 1554, in which, despite the restrictions of size, one observes the woman's breasts – exposed and pert – and the barely veiled body surrounded by an ample cloak billowing in the wind, in an invention which is quite alien to Vasari's model. In the past, scholars had already noted the direct correspondence of the Pitti *Patience* with that sculpted

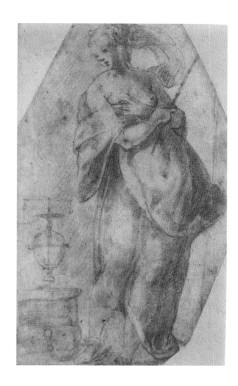

17

Girolamo Mazzola Bedoli
Allegory of Patience
Red chalk on paper, 132 × 81 mm
Private collection

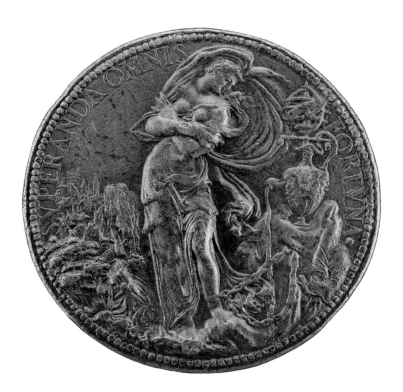

18

Pompeo Leoni
Medal of Ercole II d'Este
Bronze, diam. 65.5 mm
Florence, Museo del Bargello

on the pedestal of Ercole's bust,[58] and also with the Patience of Pompeo
Leoni's medal, but had supposed a direct affiliation from Vasari, as
Minerbetti's painting was then considered to be the canvas in the Palazzo
Pitti. However, in relation to Vasari's actual prototype, the affiliation will
have to be turned on its head: the *Patience* by Camillo and Bastianino
Filippi which is now in Modena must be the earliest derivation from the
Minerbetti drawing, whilst the other three works seem to us to belong
to an entirely Ferrarese group, representing the stylistic evolution of
the image in tune with a courtly aesthetic adept at enveloping figurative
inventions with sensuality.

 If we study the canvas in Palazzo Pitti with eyes unblinkered by the
attribution to Vasari, we will notice how it is the only work which precisely
replicates the invention of the billowing cloak in Leone's medal, as if
it were the final, fully developed stage of a linear evolution, or else the
prototype of an entirely Ferrarese development, internal to the court. It
is also the exact model for the hourglass topped by an armillary sphere.

In addition to this observation, the painterly style of the Pitti work also seems far removed from Vasari's fragmented surfaces, and also from the Florentine style of Michelangelo's drawings which influenced Gaspare Becerra, who favoured glassy surfaces in his paintings, which are never descriptively naturalistic. In comparison to the terse execution of the work we present here, the mellifluous handling of the paint in the work in Palazzo Pitti seems to us completely in keeping with an execution by Camillo and Bastianino Filippi. Comparing individual elements of the design and painterly handling, as if in a Morellian analogy, we find exact matching details between the Pitti painting, the *Patience* which is now in Modena, and other works resulting from the collaboration between the two artists. Already in the lower section of the two works we see a soft rendering of the paint defining the flesh and the rocks that is to be associated with Emilian artists, directly influenced by Correggio. If we then compare the details in the lower parts of the paintings (figs. 19, 20), we find an identical undulating pattern of folds in the garments, with the same alternating green and grey-purple hues, and, finally, a similar anatomy in the legs and feet, with a rounded big toe and nails that are never squared, nor sculpturally defined, as is always the case in works by Vasari or artists from his workshop.

The influence of Michelangelo, which is more evident in the Pitti painting than in the work in Modena, is not really fundamental to the painting, but seems to be confined to the physical proportions of the figure, in line with a widespread convention among artists in the middle part of the sixteenth century. Nevertheless, Michelangelo's influence is present, although cloaked in a thin, painterly coating from Emilia. The striking influence of a painterly language tuned to naturalistic representation is visible in the rocks teeming with roots and flowering plants, while the elegance of the golden flickering highlights on the bronze details of the water clock (with a figure straddling a ram) are worthy of Parmigianino. It is precisely in the works executed by the young Bastianino when still buoyed by the rigour of Camillo Filippi's draughtsmanship that we find such a soft and overall use of highlights, entirely foreign to Tuscan and Roman painting. Consider, for instance, the *Annunciation with Saint Paul* in the church of Santa Maria in Vado in Ferrara (fig. 22), painted, according to Alessandra Pattanaro, between 1552 and 1556 by the two artists in close collaboration. According to

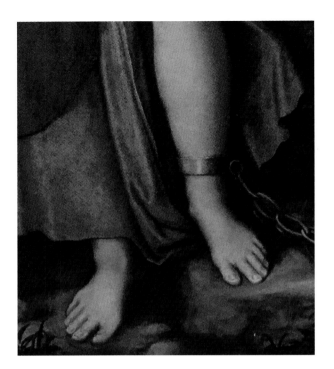

this scholar, the monumentality (influenced by Michelangelo) which brings majesty and power to the figure of the Virgin is to be ascribed to Bastianino, then freshly returned from Rome.[59] The style of this work, in our opinion, seems perfectly coherent with that of the Pitti *Patience*, also comparing the creamy paint used in the altarpiece to render the softness and pliability of the flesh of the *putti* around the figure of God the Father and that in the legs and breasts of the woman in the work in Palazzo Pitti.

Bastianino's greater contribution to the Pitti *Patience* than to the one in the Galleria Estense in Modena may have strengthened the Michelangelesque element in the figure, which corresponds to the earliest autonomous works by the artist, for instance the *Annunciation* in the Pinacoteca in Ferrara or the *Transfiguration* in the shrine of St Christopher in the Certosa di Ferrara, formerly at Rovello Porro (fig. 23), in which the absence of the father's (Camillo's) control over the design leads to a freer execution, and to an expansiveness in the anatomy of the figures not as yet present in the Pitti painting, which we believe to be the fruit of a late collaboration between father and son.

19

Camillo and Bastianino Filippi
Allegory of Patience
Detail of fig. 7

20

Bastianino and Camillo Filippi
Allegory of Patience
Detail of fig. 3

21

Giorgio Vasari
Allegory of Patience
Detail of fig. 1

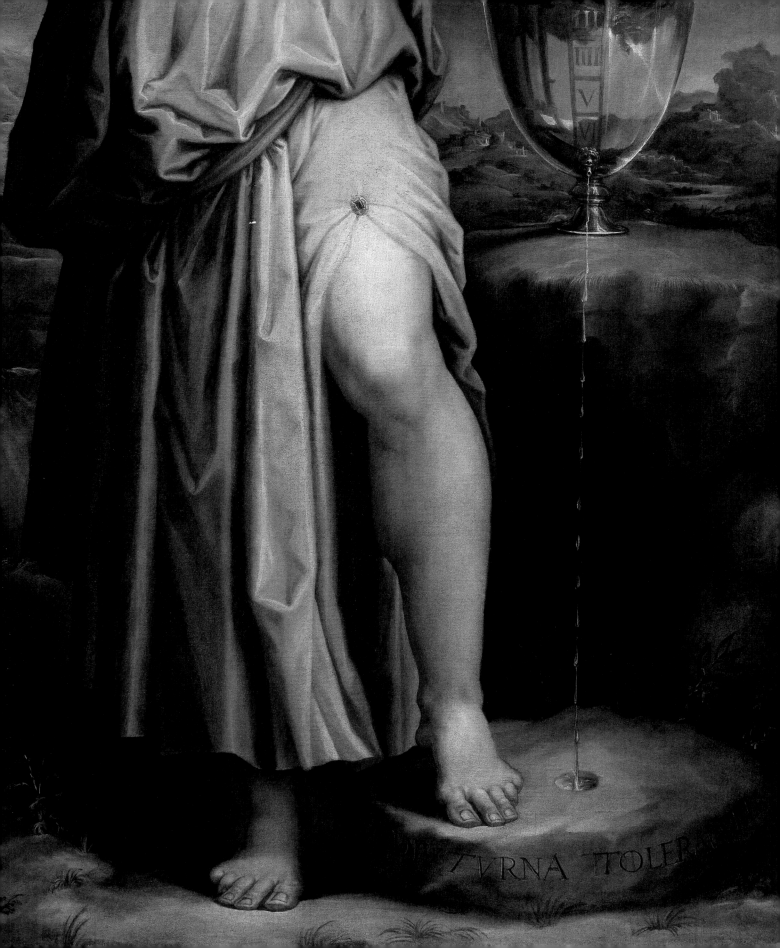

22

Camillo and Bastianino Filippi
The Annunciation with St Paul
Oil on panel transferred to
canvas, 400 × 258 cm
Ferrara, Santa Maria in Vado

23

Bastianino and Camillo Filippi
The Transfiguration
Oil on panel, 460 × 218 cm
Ferrara, Certosa, Tempio di
San Cristoforo

We can therefore put forward the hypothesis that the Pitti painting also was a work executed for the castle in Ferrara as part of the allegorical cycles commissioned by Ercole II, perhaps that very "*paralello fondato*" for the ceiling in the room next to the one where the *Patience* hung, for which Camillo Filippi was paid in 1556. If this were the case, it would also explain the reference to Parmigianino in the first inventory record of the collections of Cardinal Leopoldo de' Medici. Even without the comfort of documents relating to the collection history of the work, it is difficult to believe that in 1675, in Florence, a work by Vasari originating from the Florentine collection of the Minerbetti family could have been confused with a work by Francesco Mazzola il Parmigianino. That name in the Pitti inventory may have resulted either from a stylistic reading of the work or from a provenance which included an acquisition in Emilia, in common with many other works brought to Florence to assuage the collecting cravings of Leopoldo de' Medici. Indeed, there is no reference to the painting in any of the earlier Medici inventories, so that the record dating from 1675 is thought to mark its entry into the Florentine collections.[60]

The rediscovery of Giorgio Vasari's painting has therefore allowed for both a stylistic and an iconographic classification of the derivative works which are more or less contemporary with the *Patience* painted for Bernardetto Minerbetti, installed in the Florentine residence of the Bishop of Arezzo. The Minerbetti family owned a *palazzo* in via Tornabuoni and another in via della Vigna Nuova, above the gateway of which one can still see the family crest with its three swords. The painting was to be set in a frame which, from the descriptions, would appear to have been part of the architecture, and was placed (according to the exchange of letters between Vasari and Minerbetti) at the centre of a decorative scheme which also featured lunettes, in one of the ground-floor rooms of one of the two *palazzi*. However, the substantial transformations undergone over the centuries by the two buildings do not allow us to identify where precisely Vasari's cycle was placed. The stylistic evidence and the quality of Giorgio Vasari's painting have nevertheless added a vital element to the history of the *Allegory of Patience*, allowing us better to understand the celebrity of one of the best-known Florentine allegorical inventions of the mid-sixteenth century, in a composition which enjoyed great renown in Tuscany and Emilia well into the following century.

Michelangelo's "invenzione"

An examination of the later allegories of Patience, through the analysis of paintings and drawings which with the passing years became increasingly remote from Vasari's original prototype, would bring the discussion into new fields of enquiry, relating to the different means of construction of allegories in the sixteenth and seventeenth centuries, a subject which would lead us too far away from the focus of this essay.[61] It remains to observe, rather, how far the *Patience*, in its simplicity, is removed from the mass of symbols and attributes so dear to Vasari's practice, and stands as a lone example in the panorama of grand allegorical compositions conceived by the artist. We need only compare the *Allegory of Justice* painted for Cardinal Alessandro Farnese in 1543 (fig. 24), or else the *Allegory of Contentment*, described by Vasari himself in a letter to Minerbetti, in order to understand what Michelangelo's contribution might have been to the invention so ardently desired by the Bishop of Arezzo. If the figures of *Justice* and *Contentment* are the fruit of Vasari's training as a youth alongside the Aretine Pollastra (whose capacity for invention of allegories full of conceits Rosso Fiorentino had also admired), and also of the Medicean court's allegorical vocabulary (emblematic of which is the dedication of Valeriano's *Ieroglyphica* to Cosimo de' Medici in 1556),[62] the *Patience* appears as an *unicum* in the corpus of Vasari's works, its meaningful symbols reduced to a bare minimum.

The almost complete absence of meaningful attributes in favour of meanings expressed rather through the gesture and posture of the figure is an indication of how much the Minerbetti *Patience* owes to Michelangelo, to whom the sources attribute the conception of the work. "I am awaiting Patience with great longing, formed by your blessed hands and devised (*sghiribizzata*) by that grand old man whom everybody admires and rightly honours",[63] wrote the Bishop of Arezzo to Vasari. In common with Bartolomeo Bettini, whose *Venus and Love* on Michelangelo's design was painted by Pontormo, Minerbetti, too, contented himself with a work in which Vasari's brush had given form to an idea conceived by Michelangelo, given that only Michelangelo's would be divine. As is well known, Michelangelo was always averse to

the use of codified symbols, so much so that the identification – and hence meaning – of certain of his allegorical figures is often conveyed only by formal and poetic suggestions, by gestures, or else by written records, but rarely by specific emblematic elements. There are countless examples; suffice it to mention the *Slaves*, or else the portraits of the Dukes in the San Lorenzo New Sacristy, who cannot be identified on the basis of any repertoire of symbols, as is also the case with the figures of *Day, Dawn* and *Dusk*, since it is only *Night* among all the figures of the Medici tombs that bears a night bird and a star as sculpted attributes. In the other sculptures, no symbol allows us to identify the figures, which vary only in the feminine or masculine nature of the part of day they represent. The understanding of the meaning of those figures stretched out on the tombs was therefore entrusted purely to poetic suggestion – for instance the angle of the head which suggests the decline of day in the figure of *Dusk* (fig. 25), or the rising of day in the figure of *Dawn* (fig. 26), or sleep for *Night*. As the four figures represent the different degrees of daylight, the finish of the individual statues could also be used to allude to the influence of light on the perception of the sculpted surfaces. The reading of the work is therefore entrusted to the different degree of finish of the marble, which varies in gradations from figure to figure – from *Night*, in which the marble is the most polished, to *Day*, in which the marble has the roughest surface of the four, whilst, of the intermediate figures, *Dusk* has the more diffuse finish and *Dawn* a cruder and sharper one.[64]

Such a cryptic and suggestive level of communication, unattainable by means of codified symbols (the latter transmittable through printed repertories such as Valeriano's *Ieroglyphica* referred to above), is therefore recognizable as a characteristic of Michelangelo's mind. It is to be found only in works conceived directly by him, whereas the monumentality of his figures, by the middle of the sixteenth-century, becomes common usage among artists of all extractions. One should therefore ascribe directly to Michelangelo not only the unusual, androgynous and sculptural qualities of the woman representing Patience in Minerbetti's work but especially the sparseness of gestures, and the absence in Vasari's painting of any symbol with the exception of the clock – emblem of time and patient waiting, but also a metaphorical literary citation. Considered from this angle, the painting seems to us

24
Giorgio Vasari
Allegory of Justice
Oil on panel, 352 × 252 cm
Naples, Museo di Capodimonte

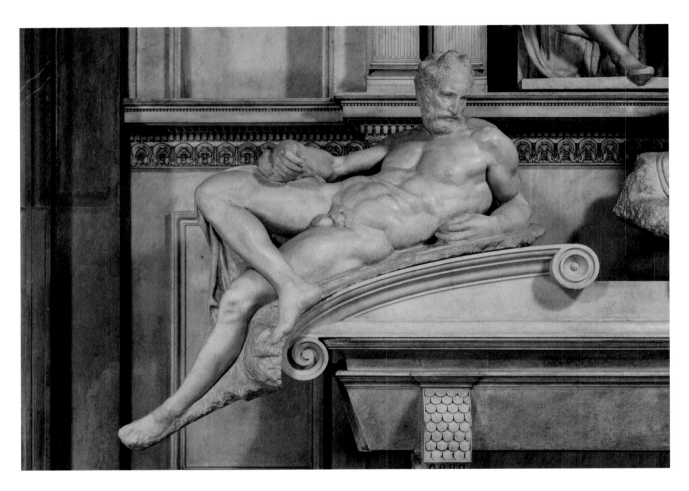

25
Michelangelo
Dusk
Marble
Florence, Cappelle Medicee
(San Lorenzo, New Sacristy)

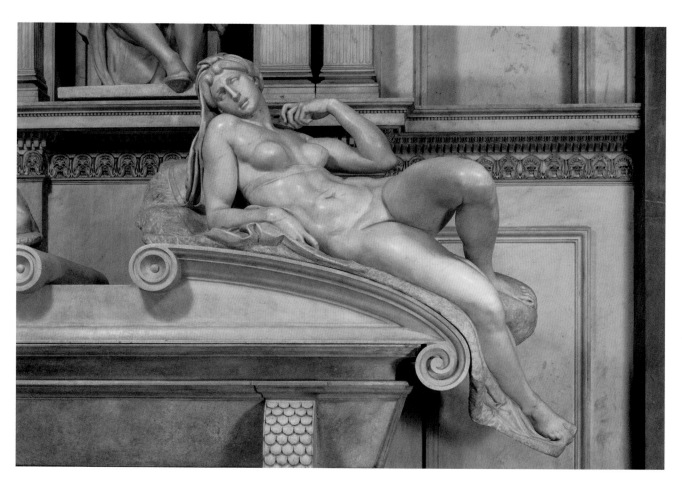

26

Michelangelo
Dawn
Marble
Florence, Cappelle Medicee
(San Lorenzo, New Sacristy)

to belong to Michelangelo not only in its forms, but especially in its 'invention', and precisely because of this it is unique within Vasari's *corpus* of works.

As the century progressed, Michelangelo's attribute-free inventions would be criticized in Counter-Reformation literature because they lacked that simple power of communication required for the "judgement of the many". Raffaello Borghini himself, in *Il Riposo,* clearly distinguished between the "well observed invention" of the beautiful figure of *Night* and the three other statues, "because in addition to representing her in the act of sleeping, he gave her a moon on her forehead, and the night bird at her feet: things which indicate Night".[65] The other three figures, on the other hand, although judged by Borghini "not only beautiful, but marvellous" as far as the "attitudes" and the "distribution of the limbs" were concerned, were criticized in relation to the "invention, as they do not bear any of the symbols given to them in antiquity, in order to recognize what they represent". Had Michelangelo not divulged their names, Borghini continues, nobody, even if a connoisseur of art, could have recognised them "as no symbol identifying them is visible, to illustrate [their meaning]". "The absence of meaningful visible emblems on the figures is very annoying for those beholding them." Borghini concludes: "… as it is impossible to guess what they are".[66]

Had Borghini written on the subject of the *Patience* which Vasari painted almost without attributes, based on Michelangelo's *invenzione,* he would probably have expressed similar reservations as those meted out to the figures in the New Sacristy, as the cultural change brought about by the Counter-Reformation would not have accepted an allegory with the meaning entrusted more to the pose of a figure than to symbols as signifiers. In complete contrast to the Michelangelesque *Patience* was Vasari's concept for the allegory of *Contentment,* as described by him in a letter to Minerbetti – a painting conceived in its entirety by Vasari which, had it been painted as a pendant for the *Patience,* would have shown the distance separating him from Michelangelo. The wealth of symbols that Vasari describes as requisite to the allegory of Contentment reflects instead his inclination to prolixity and rhetorical expatiation, based on a conventional use of verbal images, leading to an outpouring of illustrative symbols even in certain of the subjects in the

27
Giorgio Vasari
Allegory of Patience
Detail of fig. 1

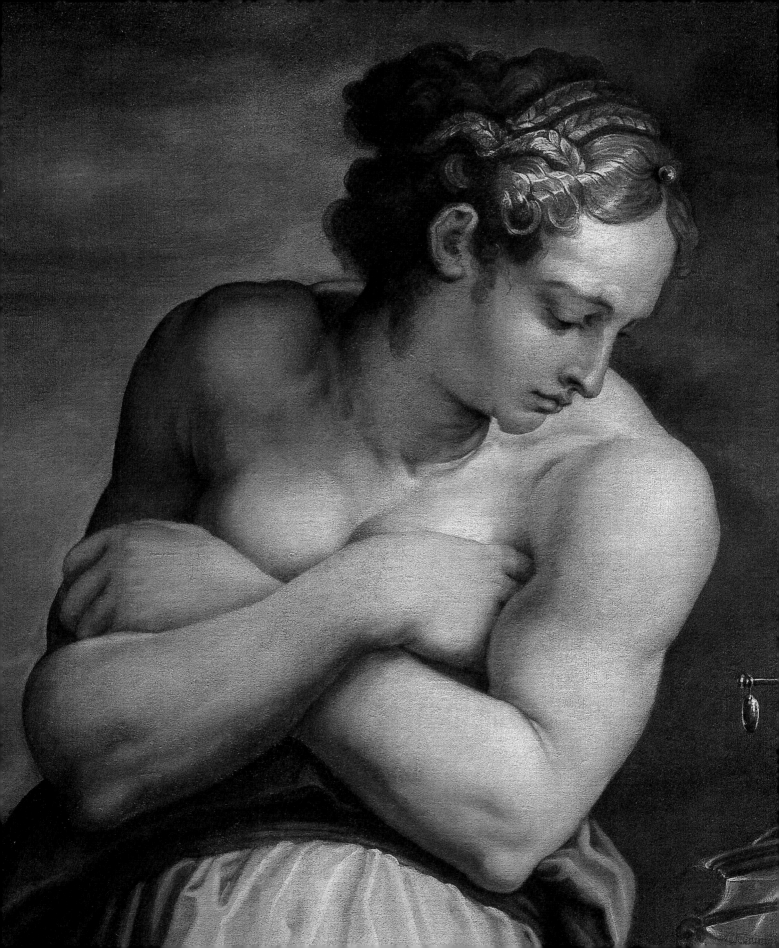

decoration of the Palazzo Vecchio, or in the panels with profane subject matter he painted – an approach which appears to us as the complete antithesis to Michelangelo's 'inventions'. In 1552, however, the disparate approaches of Michelangelo and of Vasari found a synthesis in this allegory of *Patience* which re-emerges today as a focus of critical debate, and is perhaps the final example of harmonious concord between a model described as divine in the Torrentina edition of Vasari's *Lives* published only two years earlier and its inflection in the Florentine painterly language of the time of Cosimo de' Medici.

1 K. Frey, *Il carteggio di Giorgio Vasari / Der literarische Nachlass Giorgio Vasari*, Munich 1923–30, 2 vols. (hereafter Frey 1923–30), I, pp. 307 and 308–09.

2 On Vasari's painting which now hangs in the Gallerie dell'Accademia in Venice, see the entry by Giulio Manieri Elia in *Giorgio Vasari e l'Allegoria della Pazienza*, catalogue of the exhibition (Florence, Galleria Palatina di Palazzo Pitti, 26 November 2013 – 5 January 2014), edited by A. Bisceglia, Leghorn, 2013, pp. 54–57.

3 On the collection history of the painting and the different attributions, see the entry on the painting by A. Bisceglia in *Giorgio Vasari e l'Allegoria della Pazienza*, op. cit. n. 2, p. 58. See also the entry on the painting in *Leopoldo de' Medici principe dei collezionisti*, catalogue of the exhibition (Florence, Galleria Palatina di palazzo Pitti, 7 November 2017 – 25 February 2018), edited by V. Conticelli, R. Gennaioli, M. Sframeli, Livorno 2017, p. 533.

4 For the sequence of attributions of the Palatine painting, see again A. Bisceglia in *Giorgio Vasari e l'Allegoria della Pazienza*, cit. n. 2, pp. 58–61.

5 On the attribution of the painting to Gaspar Becerra, see, in chronological order, B. Agosti, A. Bisceglia, *Per Giorgio Vasari e Gaspar Becerra: il caso della* Pazienza *della Galleria Palatina*, in 'Atti e Memorie dell'Accademia Petrarca di Lettere Arti e Scienze di Arezzo', LXXII–LXXIII, 2012, pp. 73–88.

6 *"El Beceri levò certi bruscoli, che eron caduti et appiccicatisj a quella Madonna della Gostanza, et stasera credo che acconcierà la Patienza, et tutto ha molto lodato"*: Frey 1923–30, I, p. 323.

7 *"… una femmina ritta, di mezza età, né tutta vestita né tutta spogliata, acciò tenga fra la Ricchezza e la Povertà il mezzo, sia incatenata per il piè manco per offender meno la parte più nobile, sendo in libertà sua il potere con le mani sciolte scatenarsi e partirsi a posta sua. Aviamo messo la catena a quel sasso; e lei cortese, con le braccia mostra segno di non voler partire, finché el tempo non consuma le gocciole dell'acqua la pietra, dove ella è incatenata: la quale a goccia a goccia escie della eclissidera, oriuolo antico, che serviva agl'oratori mentre oravano. Così ristrettasi nelle spalle, mirando fisamente quanto gli bisogna spettare che si consumi la durezza del sasso, tollera e spetta con quella speranza che*

amaramente soffron coloro che stanno a disagio per finire il loro disegno con pazienzia. Il motto mi pare che stia molto bene e a proposito nel sasso: 'Diuturna tollerantia'"*: Frey 1923, pp. 312–14; the letter is dated 14 november 1551.

8 *"Tornai lunedì qui, dove ho trovata la mia Pazienza di vostra mano, così ben disegnata, che e' si vede ben che veramente la patisce; e se io trovassi che (chi) me la pintassi così viva in una tela di tre braccia, io contenterei esso sì bene"* and *"andrò cercando di chi mi contenti, se qui sia possibil trovar e non trovando, sarete di nuovo affrontato da me, acciochè così troviate chi in tela me la accomodi"*: Frey 1923–30, I, pp. 312 and 317. The record is dated 28 November 1551, the italics are the author's, to indicate that canvas was the planned support.

9 *"… in così bassa cosa hanno quelli adoperato l'ingegno et voi l'ingegno e affaticata la mano"*. J. Kliemann, in *Giorgio Vasari. Principi, letterati e artisti nelle carte di Giorgio Vasari*, catalogue of the exhibition, edited by L. Corti, M. Daly Davis, C. Davis, J. Klieman (Arezzo, 26 September – 29 November 1981), Florence 1981, pp. 131–33, although referring to the painting in the Palazzo Pitti which at the time was considered autograph, had deduced from the sources that the canvas delivered to the bishop had been in the end executed by Vasari himself, in 1552. Klieman referred to the letter of 7 January 1551 in which the painting is discussed: Frey 1923–30, I, p. 341.

10 *"… e poiché io son privo per mia mala fortuna di non poter haver di sua mano* (Michelangelo) *qualche cosa, siami almeno concesso dalla bontà sua, che io possa godere in vita mia del suo infinito ingegno qualche cosa a mia fantasia, e sia questa: Che e' vi dica come si debbe a juditio suo dipinger' la Patienza, la quale, come a bocca vi dissi è la mia impresa e da me fu presa in quei tempi che essendo giovanetto, al servitio di mio zio così strano et arabico, mi bisognava, oltre a mille bassi servitii che io esercitavo, comportare infinite ingiurie. Impero conoscendomi povero e abandonato, mi resolvei, che la Patienza mi dovesse condurr'a questo grado, al quale mercie di Jesu tengo con molto contento"* Frey 1923–30, I, p. 307.

11 *"… aspetto con molto desiderio la Patienza, formata dalle vostre benedette manj et ghiribizzata insieme da quel grandissimo vecchio che tutto 'l mondo et ammira e meritamente honora"*: ibid., p. 310.

12 Ibid. On the autograph nature of the painting received by Minerbetti, proven by this letter, also see Kliemann in *Giorgio Vasari. Principi, letterati e artisti nelle carte di Giorgio Vasari*, op. cit. n. 9, pp. 131–33.

13 See B. Agosti, 'Frustoli vasariani. Su alcuni artisti, amici e committenti nel carteggio di Giorgio Vasari', *Prospettiva*, 137, 2010, pp. 97–102.

14 The letter, known through a copy by Giorgio Vasari the Younger, is dated by Frey 1923–30, I, pp. 346–56 to the months between April and June 1553.

15 *"… rilucendovi la Pazienzia che vi mandai"*: the italics are the author's, to indicate Vasari's words proving that the painting was by his hand.

16 *"… stanzaccia terrena"* where *"rilucendovi la Pazienzia che vi mandai"*, *"farà il medesimo"* – the *Contentezza*. Vasari assures him that *"senza mandarvi altro disegno sarà dipinta da me a sedere, colma di letizia, in attitudine di riposo, coronata di lauro, rose e olive e palme, fra mirti e fiori, guardando il cielo con contemplazione divina … io parlo così improvisamente per satisfare più alla risposta della lettera sua che alla pittura che debbo fare"*: Frey 1923–30, I, pp. 347–48.

17 Ibid., p. 357.

18 *"Tela sì larga non si trova; bisogna torre una tovaglia"*: that is to take, to use, a damask-weave cloth such as used for tablecloths. The passage is in in Frey 1923–30, I, pp. 358–59.

19 Frey 1923–30, I, pp. 341–42.

20 *"… et veduto che nessuna delle narrate da lui si appressavono alla vostra, mi risolvei a contar' la mia tavola.et appresso mostrar el vostro disegno e la vostra lettera appresso, la quale io tengo insieme col disegno. Or qui nacque la maraviglia e il desiderio d'averlo: a che io non possetti mancar, domandandomela, per mandarlo al signor Duca"*: Frey 1923–30, I, p. 341. In contrast to what is usually believed by the critics (for example C. Occhipinti, *'Ligorio e Vasari. Sulla Pazienza di Ercole II d'Este e su Girolamo da Carpi*, Horti Hesperidum, VI, 2016, I, p. 213) Minerbetti wrote to say that he had only shown Vasari's letter and drawing, and not the painting.

21 Frey 1923–30, I, p. 341

22 Ibid.

23 *"il che ho sfacciatamente negato"*, ibid., p. 342

24 *"… voi verrete qui, e invero pensereno al disegno*

de pannj et a qualche altra cosa, acciò che io, che tanto vi amo et ammiro le cose vostre, non sia privo di venti vostre pennellate in casa mia": Frey 1923–30, I, p. 342.

25 Frey 1923–30, I, p. 346, no. CLXXXIV.

26 "… e io l'ho fatto cavar a tempera a un buon giovane et oggi gliene manderò": Frey 1923–30, I, p. 357–58, no. CLXXXVI.

27 "… chi ha patienza, come ho sempre hauta io et l'harò finché io viva, mercé vostra che me la dipingeste così bella, mangia e' tordi a un quattrino l'uno": Frey 1923–30, II, p. 142, no. CDLXXXII; the italics are the author's own to emphasize the unequivocal execution of the Minerbetti painting by Vasari himself.

28 "… essendo dunque trasferitomi in Arezzo, per di lì venirmene a Fiorenza, fui forzato a fare a monsignor Minerbetti, vescovo di quella città, come a mio signore et amicissimo, in un quadro grande quanto il vivo, la Pacienza, in quel modo che poi se n'è servito per impresa e riverso della sua medaglia il signor Ercole duca di Ferrara. La quale opera finita, venni a baciar la mano al signor duca Cosimo, dal quale fui per sua benignità veduto ben volentieri": from Varai's autobiography, see G. Vasari, Le vite de' più eccellenti pittori, scultori e architettori, nelle redazioni del 1550 e 1568, edited by R. Bettarini, commentary by P. Barocchi, 6 vols., Florence 1966–87, VI, p. 398.

29 "… ricordo che si fece una figura in sulla tela grande quanto il vivo per Messer Bernardetto Vescovo di Arezzo figurata per la Pazienzia, della quale se n'ebbe braccia 15 di raso rosso, che donò a Madonna Cosina mia donna, valeva scudi venti, scudi 20": G. Vasari, Le ricordanze, edited by Alessandro del Vita, Arezzo 1929, p. 73.

30 "El Beceri levò certi bruscoli, che eron caduti et appicciatisj a quella Madonna della Gostanza, et stasera credo che acconcierà la Patienza, et tutto ha molto lodato": Frey 1923–30, I, p. 323.

31 Barbara Agosti believes Costanza to have been the daughter of Ottaviano de' Medici: see B. Agosti, 'Frustoli vasariani. Su alcuni artisti, amici e committenti nel carteggio di Giorgio Vasari', op. cit. n. 13, p. 97.

32 "… tutto ha molto lodato": Frey 1923–30, I, p. 323.

33 The canvas seems to have been trimmed only very slightly at the top and bottom edges, while the original selvedge is present both on the left and the right; the slight discrepancies may also be the result of the measurements having included the frame, which may have been oval in shape but have had a rectangular painting fitted within it.

34 See A. Pattanaro, 'Il modello per La Pazienza di Ercole II d'Este, da Firenze a Ferrara, "la maraviglia e il desiderio d'averlo"', in Giorgio Vasari e l'Allegoria della Pazienza, cit. n. 2, pp. 35–45.

35 The whereabouts of this painting are unknown; it was sold at auction at Christie's, London, on 31 October 1989, lot 86, and is published in a small photograph in L. Corti, Vasari, catalogo completo dei dipinti, Florence 1989, p. 90. The figure of Patience is visible in the black and white photograph in the Zeri picture library (no. 37022), and is probably linked to the tortoise represented on the table top, symbol of slowness, as the wearing away of the stone by the dripping water would also be slow. In the same location are two pointed letters, of which the first is legible, a G, but the second is indecipherable. In this example the figure of Patience is chained to the rock, thus declaring its derivation from Vasari's drawing and not the painting.

36 The painting appeared in a Pandolfini auction, Da mercante a collezionista: cinquant'anni di ricerca per una prestigiosa raccolta, Florence, 11 October 2017, lot 5.

37 The only Florentine version in which the chain is present seems to be the one in the portrait referred to above and formerly attributed to Vasari: L. Corti, Vasari, catalogo completo dei dipinti, Florence 1989, p. 90.

38 "… la femmina ritta, di mezza età…né tutta vestita né tutta spogliata, acciò tenga fra la Ricchezza e la Povertà"; "… strettasi nelle spalle" she stares "fissamente quanto gli bisogna aspettare che si consumi la durezza del sasso" on which drips water from a "eclessidra, oriuolo antico, che serviva agl'oratori mentre oravano": Frey 1923–30, I, pp. 312–14.

39 "… tollera e aspetta con quella speranza che amaramente soffron coloro che stanno a disagio per finire il loro disegno con pazienza": ibid.

40 Cicero, De inventione, II, 54, 163–64;

41 Frey 1923–30, I, pp. 312–14; the letter is dated 14 november 1551.

42 "… non dee essere ligata, ma libera e sciolta e forte dell'animo e d'avvedutissimo e perspicace intelletto, e constante in ogni persecuzione". On this question, see C. Occhipinti, 'Ligorio iconologo e la Pazienza di Villa d'Este a Tivoli. Appunti sull'Occasione e Penitenza di Girolamo da Carpi', Italianistica, XXXVIII, 2, 2009, pp. 197–218, who, however, accepts as by Vasari the Patience of the Palazzo Pitti. Again on Ligorio, see A. Bisceglia, 'Vasari e l'allegoria della pazienza. Storia e fortuna di un tema iconografico', in Giorgio Vasari e l'Allegoria della Pazienza, op. cit. n. 2, p. 21. This subject is also dealt with by C. Occhipinti, 'Giorgio Vasari e l'Allegoria della pazienza', Acta Artis, 3, 2015, p. 133; and again C. Occhipinti, 'Ligorio e Vasari. Sulla Pazienza di Ercole II D'Este e su Girolamo da Carpi', Horti Hesperidum, VI, 2016, in particular pp. 212–16. Ligorio did not want to criticize, as Occhipinti writes, the invention of the clock, but the captivity of the figure of Patience, who Vasari himself in his letter wrote was called upon voluntarily to endure the long period of waiting necessary for the drips of water to wear away the rock.

43 For the way in which Vasari constructed his allegories, see A. Fenech Kroke, Giorgio Vasari. La fabrique de l'allégorie. Culture et fonction de la personification au Cinquecento, Florence 2011.

44 For this drawing, see the entry by Alessandro Cecchi in Giorgio Vasari e l'Allegoria della Pazienza, op. cit. n. 2, pp. 68–69.

45 For the different versions known, see the catalogue of the exhibition Giorgio Vasari e l'Allegoria della Pazienza, cit. n. 2, pp. 54–99. The only sixteenth-century Florentine version in which there is a chain, but not Annibale Caro's motto, is the anonymous one published on pp. 82–85, evidently derived from Vasari's drawing and not from the painting. The chain appears in end-of-the-century versions, such as the work illustrated on p. 89, or that by Empoli on p. 90, fig. 1, all of which derive from the drawing and not from the painting, as is also clear from the figure, which is half-undressed. Leonardo Cungi, on the other hand, eliminates the chain, but imbues the subject with a meaning which alludes rather to the patient enduring of the pains of love, judging by the arrows which surround the female figure and Cupid: see pp. 86–87 of the same catalogue.

46 See again Giorgio Vasari e l'Allegoria della Pazienza, op. cit. n. 2, pp. 62–63.

47 See the letter of 1551, Frey 1923–30, I, pp. 312–14.

48 Frey 1923–30, I, p. 346, n. CLXXXIV.

49 On this painting see again the entry by A.

Pattanaro in *Giorgio Vasari e l'Allegoria della Pazienza*, op. cit. n. 2, pp. 70–75. On this painting, see also A. Pattanaro, *Camillo Filippi "pittore intelligente"*, Verona 2012, pp. 35–47, 113–15.

50 See ibid., pp. 113–14.

51 As is suggested by A. Pattanaro in *Giorgio Vasari e l'Allegoria della Pazienza*, cit. n. 2, p. 72. The use of the word *"conzare"* should be noted (to adjust, put right), corresponding to the *"acconciare"* used in Minerbetti's letter to Vasari to describe the work carried out by Becerra in an evening.

52 Again, see A. Pattanaro, *Giorgio Vasari e l'Allegoria della Pazienza*, op. cit. n. 2, p. 72.

53 "… *uno telaro in cornise de nogara per meterli dentro il Retratto della Patientia"*: see A. Pattanaro, *Camillo Filippi "pittore intelligente"*, op. cit. n. 49, p. 79.

54 Ibid., pp. 40, 79–80.

55 "… *inequivocabilmente di un quadro da soffitto parallelo ad un pendant dipinto nella camera vicina, cioè quella della Pazienza, intelaiato e incorniciato"*: ibid., p. 40.

56 On the subject of *'Occasione'*, see ibid., pp. 43–44.

57 The attempt is made by Alessandra Pattanaro, who offers a general reading of the decoration, which also comprised the representations of *Diligence* and *Fame*, which are now in the Royal Collection in England. See A. Pattanaro, 'Il modello per La Pazienza di Ercole II d'Este, da Firenze a Ferrara, "la maraviglia e il desiderio d'averlo"', in *Giorgio Vasari e l'Allegoria della Pazienza*, cit. n. 2, pp. 42–43; see also eadem, *Camillo Filippi "pittore intelligente"*, op. cit. n. 49, pp. 44–47.

58 See A. Pattanaro, *Camillo Filippi "pittore intelligente"*, op. cit. n. 49, p. 38.

59 Ibid., pp. 51–61.

60 See the entry for the painting in *Leopoldo de' Medici principe dei collezionisti*, op. cit. n. 3, p. 533

61 For an analysis of drawings and derivations from Vasari's model, but also for autonomous inventions of the *Allegory of Patience*, see again *Giorgio Vasari e l'Allegoria della Pazienza*, op. cit. n. 2, pp. 58–99.

62 On Vasari's methods in the composition of allegorical subjects in paintings, see again A. Fenech Kroke, *Giorgio Vasari. La fabrique de l'allégorie. Culture et fonction de la personification au Cinquecento*, op. cit. n. 43. See also L. De Girolami Cheney, 'Giorgio Vasari's allegory of prudence mirroring Alciato and Valeriano's emblems', *Emblematica*, 17, 2009, pp. 239–56.

63 Cited n. 11; Frey 1923–30, I, p. 310.

64 On the gradations of finish in Michelangelo's statues in the New Sacristy, see C. Falciani, 'Un dipinto ritrovato del Bronzino e alcuni suoi pensieri sulla pittura e sulla scultura', *Paragone*, 125 (790), 2016, pp. 3–24.

65 "… *perchiocché, oltre al farla in atto di dormire, le fece la luna in fronte, e l'uccello notturno a' piedi: cose che dimostrano la Notte"*: R. Borghini, *Il riposo*, Florence 1584, p. 65.

66 "… *e come che l'Aurora, il Giorno, et il Crepuscolo sieno figure quanto all'attitudini, et al componimento delle membra non solo belle, ma maravigliose, nondimeno non so io che dirmi dell'invenzione, poiché elle non hanno insegna alcuna di quelle, che davano loro gli antichi, per falre conoscere per quelle, che sono state finte (…) non si vedendo loro contrasegno ciò dimostrante (…) certo che il non vedere alle figure l'insegne dicevole reca grandissima noia a chi le rimira, disse il Michelozzo, poiché non si può indovinare quello che ele si sieno"*: ibid., pp. 65–66.

ISBN 978-1-911300-82-3 (English edn)
ISBN 978-1-911300-84-7 (Italian edn)

British Library Catalogue in Publishing Data

A CIP record of this publication is available from
the British Library

Translation from the Italian by Helen Glanville

Produced by Paul Holberton Publishing
89 Borough High St, London SE1 1NL
WWW.PAULHOLBERTON.COM

Designed by Laura Parker
Printed by E-Graphic srl, Verona